CRCNCL
a sursurrealistic

a sur-surrealistic **CRRCNCCL**

featuring
Liaizon Wakest
Bern Porter

and the words of
Abraham Lincoln Gillespie
November 1989

2008
XEXOXIAL
EDITIONS
West Lima Wisconsin

1st edition published in 1990. 2nd edition digitized for posterity & designed by mIEKAL aND September 2008.

ISBN 1-4404-1832-2
EAN-13 978-1-4404-1832-7

⊚copyleft Mark Melnicove,
literary executor for Bern Porter
216 Cedar Grove Rd., Dresden, ME 04342
<mmelnicove@adelphia.net>

Xexoxial Editions
10375 County Highway Alphabet
La Farge, WI 54639

perspicacity@xexoxial.org

www.xexoxial.org

THE FOLLOWING BOOK IS THE VIDEOSCRIPT FOR A 30 MINUTE VIDEO OF THE SAME NAME

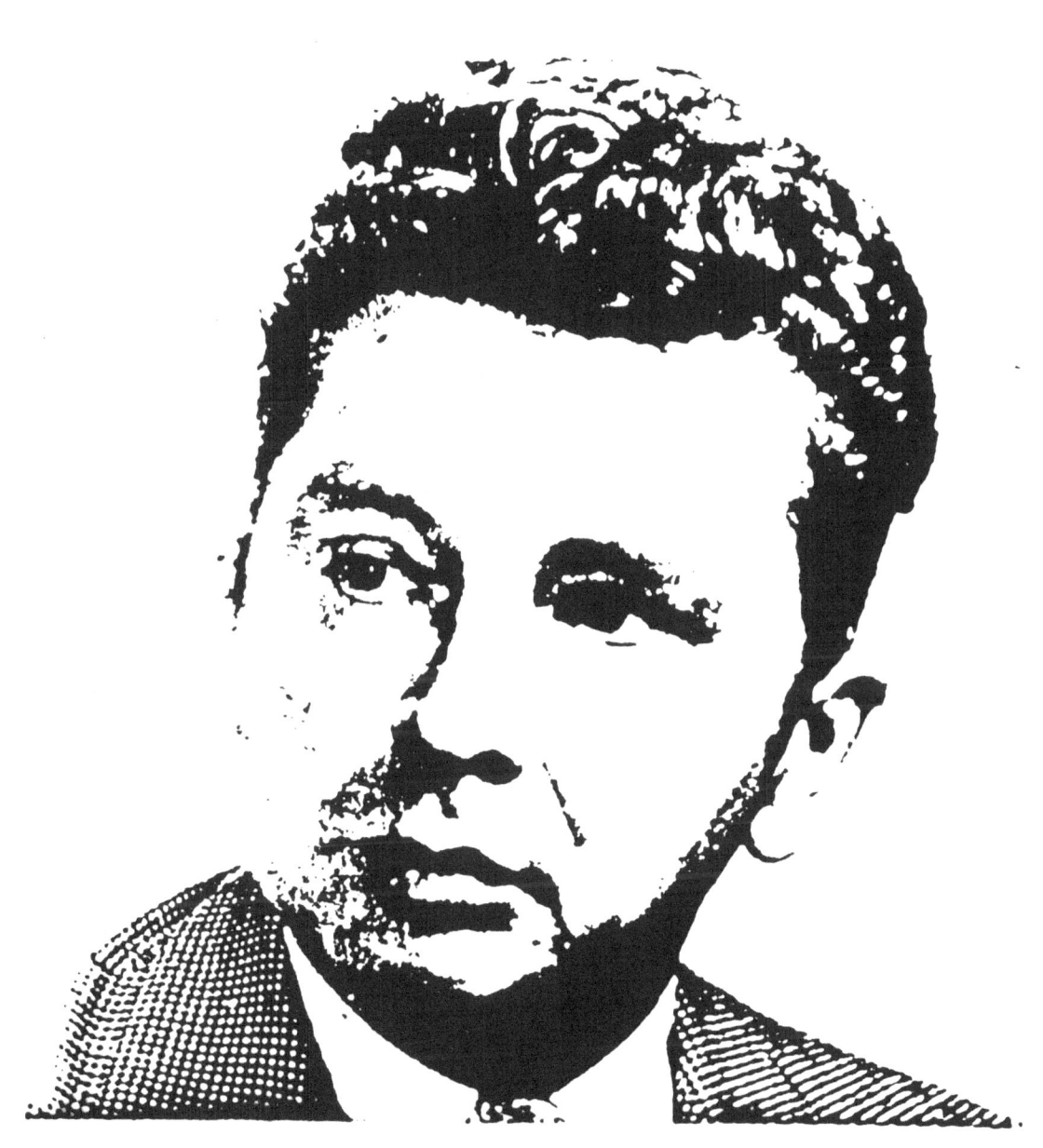

Bern Porter, 1941

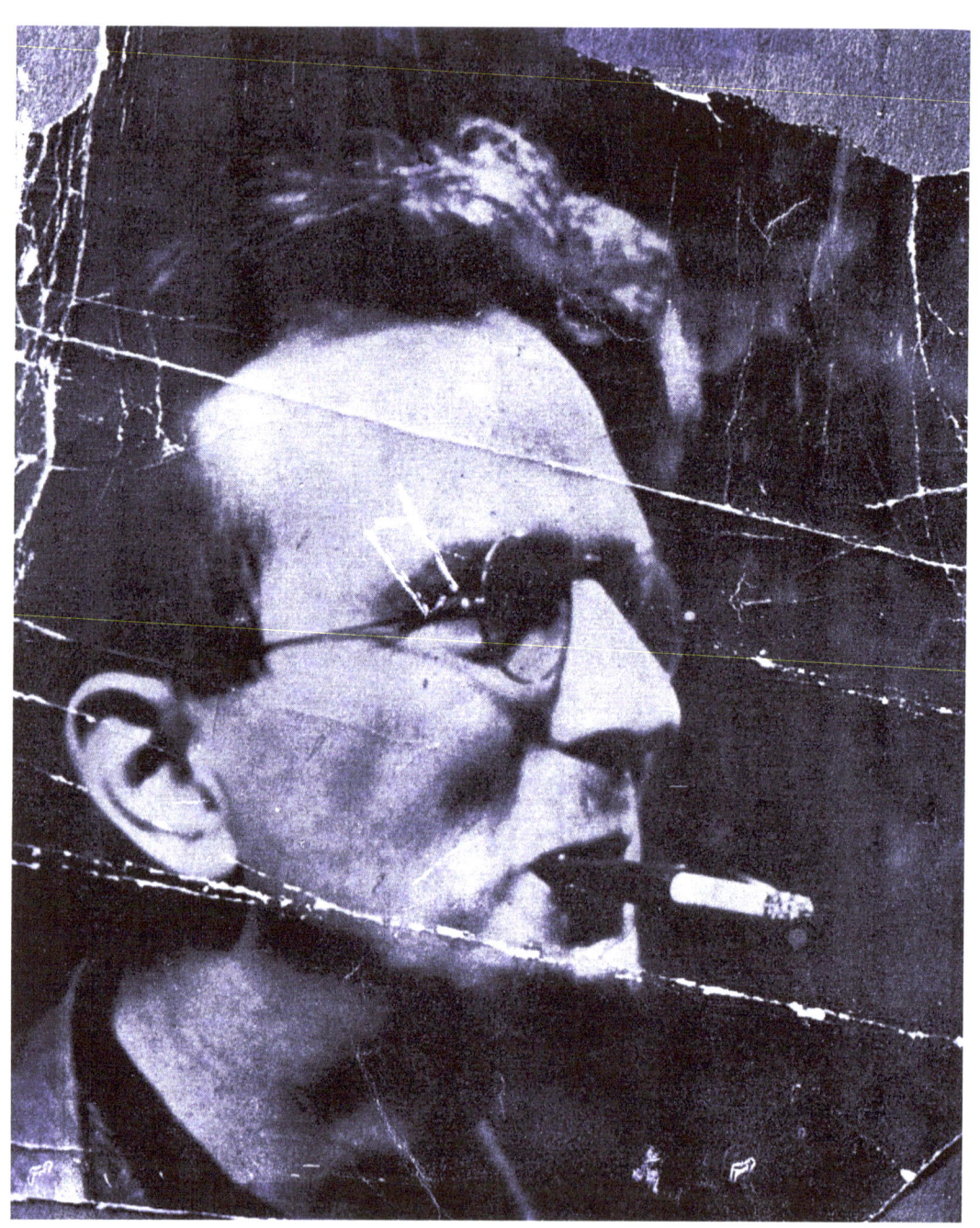

Abraham Lincoln Gillespie, 1930

Today is October 5 to get the specials Greyhound deal Belfast-Madison for Nov 13 I have to get ticket 30 days in advance Oct 13. I will do this. (got cards — thank you).

The only positive now is Nov 14–Nov 19 in Albany though I have tried to get Utica, Syracuse, Rochester, etc. in between up to Chicago. I wrote Woodland Patterns but no answer yet. Do you have any Chicago spots? Or others? The main thing is to get to Madison.

A. to make 60 minute Blues #2 — please help with stuff for us to do.
B. to make a 60 minute motion picture " " " " ...
Will do just etc. thing as you wish. — Bern

any help with reading spots appreciated

will write as I sense more

1. **Williamson Street Blues**
 Number 2
 I need real W.S. noises, sounds.
 also jews harp
 harmonica
 street organ
 60 minutes
 your words + mine.
 plus whatever

2. 60 minute Movie:
 Williamson Street (IN COLOR)
 Lauren / me / your friend down the street — her backgrounds / yours.
 your ideas + mine
 only 3 of us.
 → Surreal surreal ←
 plus sounds same type.

3. Your interview of me 60 minutes on Just state.

As of to-day Oct 11. It appears I'll get a special Greyhound Bus ticket 30 days in advance, for Nov 13 – Dec 13 or 30 days use — meaning I have to arrive in Madison before Dec 13.

As of to-day I'll be in Albany, New York Nov 13 – Nov 20 and in Chicago Nov 20 – Nov 28 — do you know any reading spots in Chicago? After the Blues 2, Movie starring L.W/B.P. the institute interview maybe there are some reading spots in Madison (?) then at end hopefully go all of us (3) to Woodland Pattern & I return to Chicago from Milwaukee. Bern.

It appears now I could/would/might arrive by greyhound in Madison soon after ~~Thanksgiving day~~

Wrote to Woodland Patterns but no reply for reading there yet.

In the movie with Larson and your friend down the street the only words to be used should come from lines of American poet Abraham Lincoln Gillespie – I have two of his poems get quotes

B.P.

forget Chicago gigs / no chicago gigs Nov
 before or after — no chicago
Spend full time thinking out scenes, gigs before wrote
situations, backgrounds, acts, doings
for a (continuous thread) of attention
hoarding images for a 60 minute
movie made in full on the usual shoe-
string no money basis.
 As far as I know arrival is Nov 28
instead get gig for 3 of us at Woodland Patterns. Mil.

Please give a lot of concentrated
thought now on 60 mm surreal
surreal color movie Williamson Street
 including acts for Watson
 clothes " "
 numbers/designs painted on his nude body
 clothes / for me
 acts
 plus stuff on nude body
 your friend's rooms, your rooms,
 etc yard
 etc. etc.
 etc. Dave.
+ stuff.
 same
 similar
 real
 etc.

The only gig that matters is Woodland Patterns in Milwaukee for me/all of us (3)/ I wrote them a month or so ago but no answer. I wrote them again today saying I'll be in care of you after Nov 28 and please set forms a December date. Please continue to help in any way. Meanwhile besides staff stuff ideas for the movie I'll need an ms or two or three for the Filues #2. Also will be bringing some old tapes to be copied and issued under your label for sale. We'll be busy!

—Steven

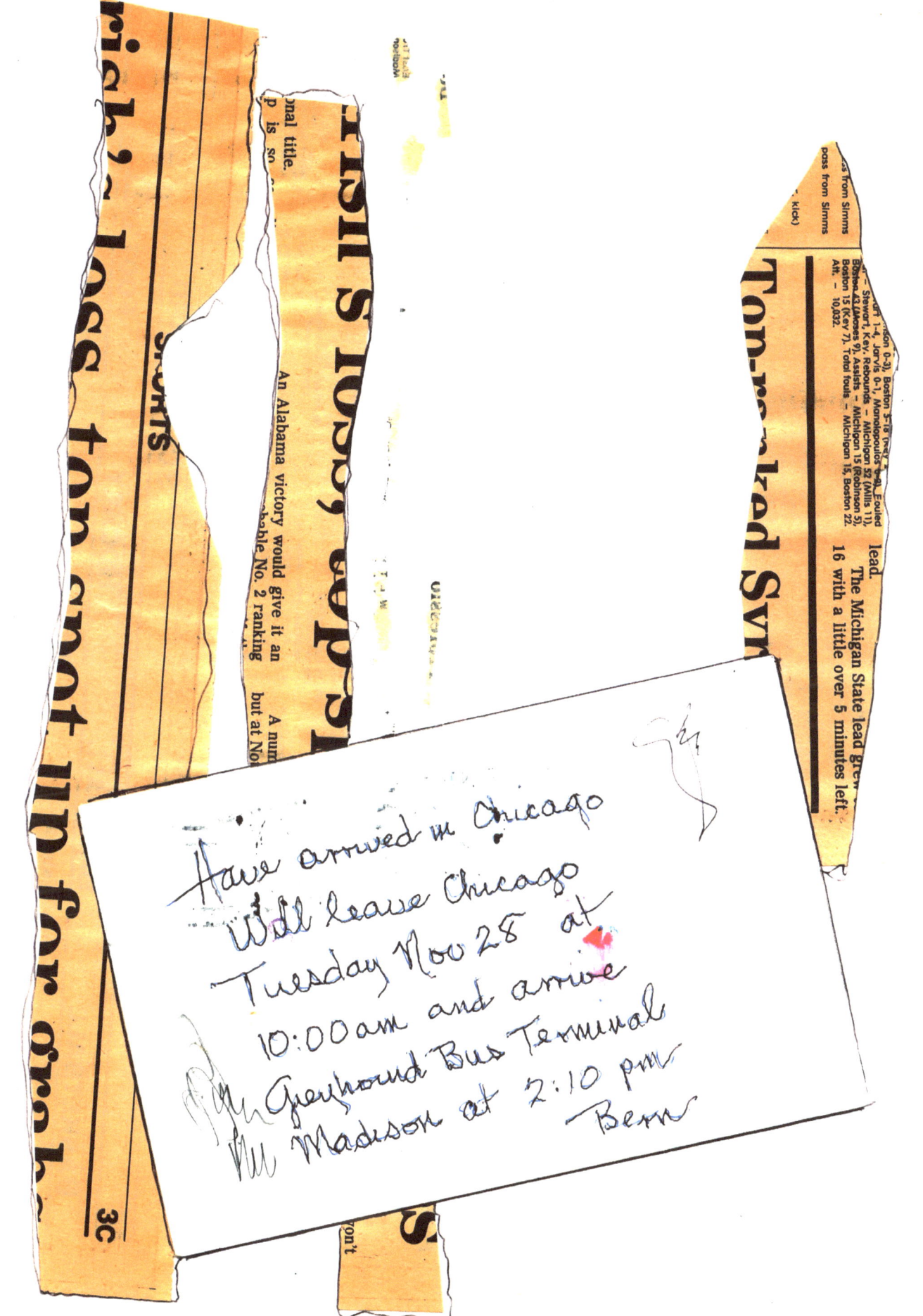

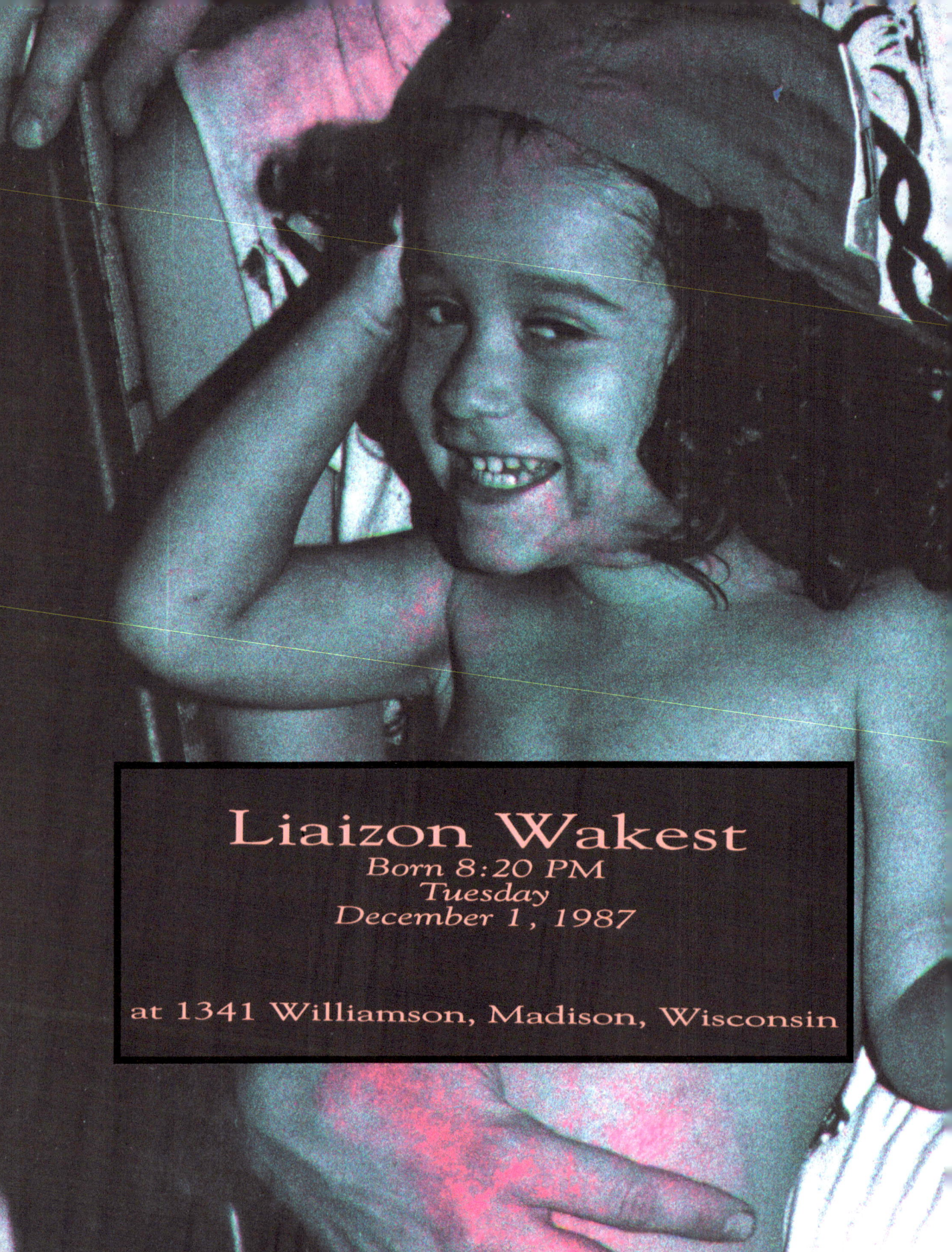

Continual panning shots – breaking in/out
of environments — in house
in yard
in stairways

with Laison in differing clothes, designs

Bern in differing nobody words, designs

How close up can video get to subject? — Bern and teeth.

line for Zon to say "WHO FOUND BERN PORTER?"

Can Higgs dance piece show scenes on ceiling as indicated in her book?

on watching his video Left Legs

General Theme — Zon is looking for Bern
Bern is looking for Zon
They finally meet on floor in front
of Taxi Sign
plus other background

Thus ① using super lighted Drake's Closet
Zon walks out in 3 different getups
Bern walks in " " " " "

② repeat above with Sophie's Closet

③ repeat above for any other closets

On using Stairs/Steps

① first sequence — beginning in basement

super lighted — panning from here to take in basement. Bern comes out of dark mass

② second sequence — *super lighted*
coming up from basement to first landing — clothes changes — face on
Bern to walk up
Zon to crawl down

③ third sequence — *super lighted*
1st floor — Bern going up — clothes back only.
Zon crawling down.

④ fourth sequence — *super lighted*
2nd floor — Bern coming up / going down } with clothes change
Zon crawling up / crawling down

PORTER

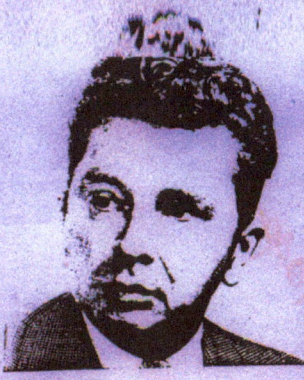

1941. Drafted into Manhattan Project, third in command under General Groves and Dr. Oppenheimer. Teaches 200,000 hillbillies in Oak Ridge area to come out of grass huts and read dials for him.

1944. Publishes Henry Miller's *Murder the Murderers* anonymously so won't lose job.

August 7, 1945. Quits Manhattan Project in response to the dropping of the atomic bomb. Starts guilt trip to last rest of life.

Bern Porter, once a nuclear physicist, is a legendary figure among a group of Fluxus writers, happeners, poets, and mail art aficionados. Now 74, he has worked in underground presses for 40 years, dispensing his own carefully honed visual poems as well as such writers as Henry Miller, when no other American dared tackle him.

Here's Your Schedule

- WASTEBASKET
- DUST PAN
- FLOUR CANISTER
- SUGAR CANISTER
- COFFEE CANISTER
- TEA CANISTER
- SERVING TRAY

BERN PORTER

FRIDAY NOV. 17 8PM at the QE2

a benefit for the Hudson Valley Writers Guild

BERN PORTER, "The Charles Ives of American Letters," now lives in Belfast, Maine at his Institute for Advanced Thinking, a unique school for drop-outs where projects in world altering with accents on betterment through atomic nutation, gravity diversion, anti-matter, solar effects, temperature differences, extra senses and theoretical physics projected to human use are carried out.

tickets: general admission $4

for more info: 430-6314

logistics by PeaceWorks

THE BOOK OF DO'S

POINT OF VIEW

The Script:

1. Abraham L Gillespie Look —
 write words on cards
 print on Bern's Body
 ↪ Zon plays with word cards
 close-ups

2. reappearing wind-up toy
 coming from different directions
 Zon's Alphabet sweater —
 Bern's
3. 4 shirts
4. continually changing clothes

Short Gillespie Words

DISHOUTS
PULSTHUG
NESTOIL
GEYNE
TRICKL
BYCITS
LIBIGO
FEARL

Long Gillespie Words

IGNORINNOCENCE
SORROWSWEATINTOCHEESEJOY
FUGUEFLIGHT-SILKSTEAM
SHEENSPRAY-EMERYCLEARS
NORMALCYAIRGULPINGS
AMOEBAWIGGLE-AWAY
WAWKSWAY-YIELDSTARTS
YEUTHANASELATE
MALEDOMINACQUIRELENTLESSIGH
TOFROMUTUPLAQUE
STRIDEMETALCRASH

Bern Porter

Bern Porter is a pioneer, 20th century avant-garde artist, who has made major contributions as a visual poet, publisher, physicist, performance artist and essayist.

The undisputed father of "found" art, Porter is a leading poet and performance artist. He has worked in underground presses for 40 years, dispensing his own carefully honed visual poems as well as the works of others. He has published over 58 books of his own work including *The Book of Do's* (1982), *Found Poems* (1972), *The Manhattan Phone Book* (1972), *The Wastemaker, 1926-1981* (1972), *Gee-Whizzels* (1978), *Dieresis* (1969) and *Sweet End* (1988). In addition to his own work, he was the first American to publish Kenneth Patchen, Anais Nin, Kenneth Rexroth, and Henry Miller's antiwar *Murder the Murderers*.

Once a nuclear physicist, Porter helped develop the cathode-ray tube, the picture tube coating that made television possible, and ionospheric broadcasting. He also worked on the Manhattan Project and on the manned space program for NASA. During the 1940's he abandoned his career as a physicist and turned his attention to unifying the arts and sciences in what he calls "Sciart."

"Some of the found poetry of Bern Porter is like this - you can open a book and see things there that look like poems, but they're laundry lists, or they're cut-up bits of ads, or pages of mail-order catalogues. Whatever. But in some way they become poems too, particularly, say, the way a really good found-poet like Bern Porter utilizes them." - Jerome Rothenberg

"When one speaks of Porter, one has to ask which Porter one is speaking of: the atomic physicist, the poet, the surrealist, the first U. S. publisher of Henry Miller and of a number of the best poets of his generation, the sculptor, the early practitioner of 'found poetry,' the graphic illustrator, etc. Most of what is most lively, technically, in the cultural environment today has been touched on by Porter at some time over the past 30 years." - Dick Higgins

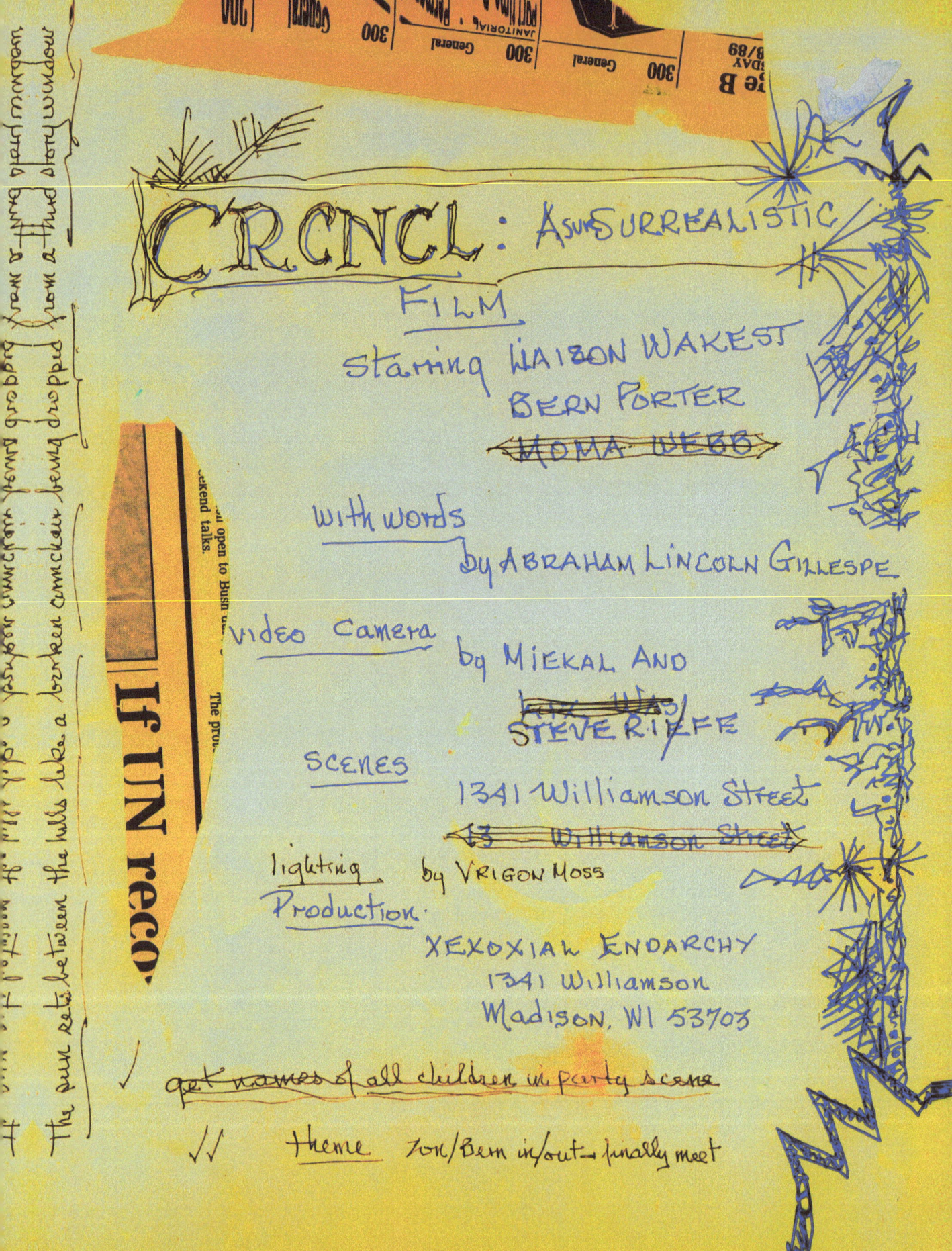

Words to be used

- ✓ on small playing cards
- ✓ " wooden blocks
- ✓ " tin cans
- ✓ " gords
- ✓ " backgrounds

on 8½ × 11" sheet page

(all from Gillespie)

ELIX	SHTURK	NONOIS
ORJOY	VTAEL	THEAT
FLECIL	SHORDTS	MEIDEA
HEROCO	NOBLEO	CUPSE
KSONG	DALIL	DNIEDDA
FORZE	GLOENDE	KIZD
ARCIEL	VENUX	ALFRESCOTY

on backgrounds either one line or more →

BOBN - CHUCLA - PWHIC
FIR - STRAVTORS - NEELEGE
WONCE - TOTEN - MISSLYONS
~~AND - O - WUS~~
TO - SOFDEN - FRANTS

~~AOMIR~~
~~HOGLA~~
~~FTEKA~~
~~HEEPF~~
~~YALI~~
~~KSHA~~
~~TAHA~~

✓ While playing with word cards, signs, blocks, toys.

numbers on cheeks every two minutes.

Liaizon Wakest
Born 8:20 PM
Tuesday
December 1, 1987

clothes change every 2 minutes (max) best every minute

Numbers designs on lovebody every two minutes (max)

1341 Williamson, Madison, Wisconsin

✓ windup toy in + out

✓ Berns right hand - changed its designs + color every two minutes
in + out

✓ Berns Found
in + out

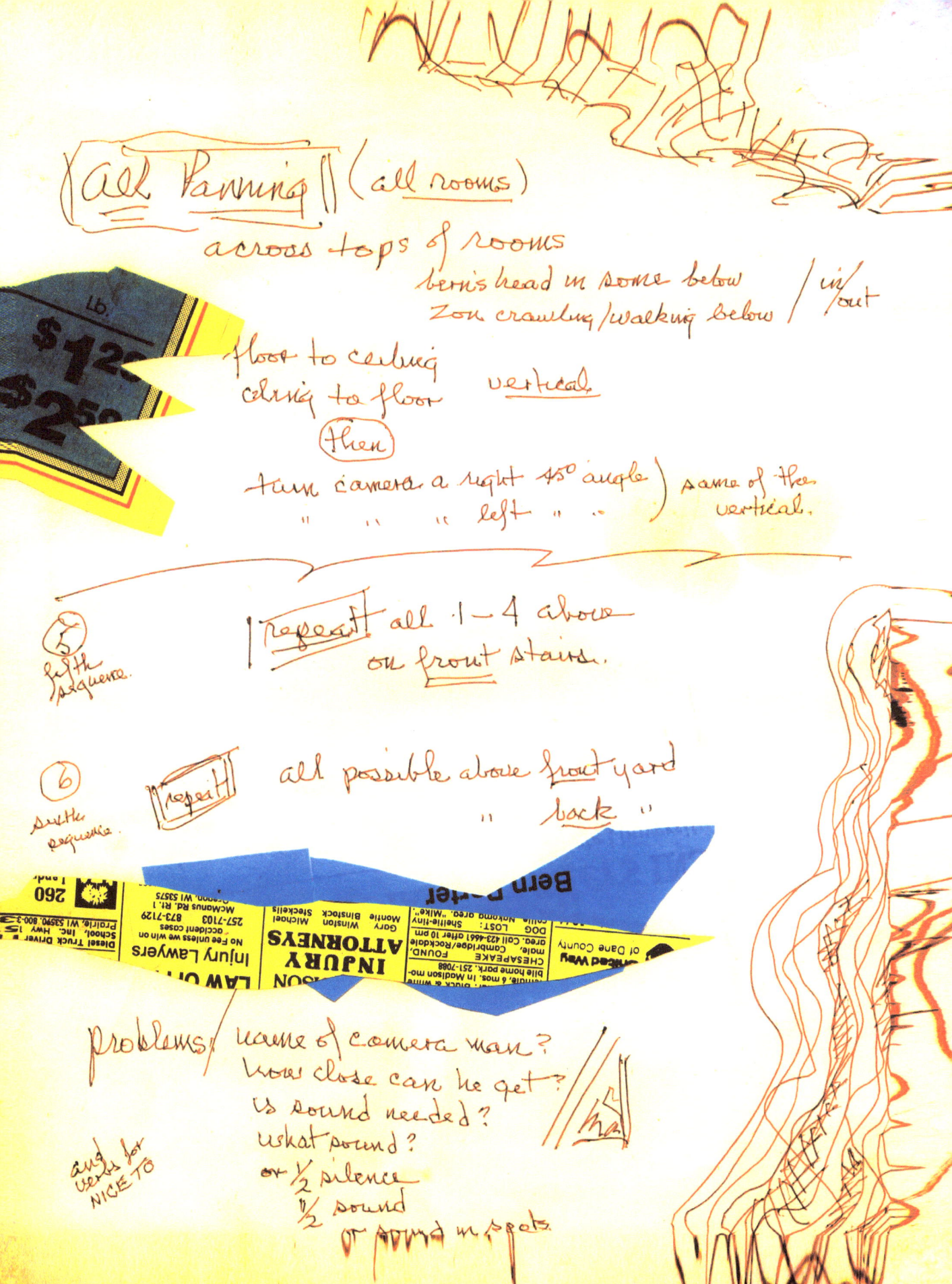

– have the computer speak Gillespie words
– do credits on the computer
– Sound of marble ramp with the stairs sequences.
– footage of Gillespies face to superimpose over Bern & Zon faces
– Zon typing on computer
– rephotography of Bern & Zon changing colors of their face

Gillespie words for

It's nice to: ———

REGROOVE
DIDDLE-DODDER
PETTIFOGG
DAME-BOUNDY JUMP
PLATFORM-SPAWN
BABY-GURLE-AND-WADDLE
DOGGEREL-IMPUTE
GRIM-FACE
ARITHMESH
LISTEN-LURK
PORTRAY-ADEQUATE
✓ BATHOS-WALLOW
NICK-EMBROIDER
LOCOMOTE-FESTER
INCESS-FURTHER
WORD-PHRASE
BLEEDPLEAD

Bern's Black T-shirt of his design

GRUDGE-FUNCT
SONE-TUMBLE-DISPLAY
CLASHMEET

CRCNCL
(BE&ZON)

Ncl eading Big Book in rocking chair

Bern + Zon drawing/painting in BIG BOOK (or watching as liz's hand draws/paints)

bern + zon hiding behind pages of BIG BOOK

Zon + Bern (playing) hiding behind/on either side of a (curtain)

← Bathtub scene.

→ Black & White figure on the wall

me nude?
Ton clothed?
???

arithmesh

PLATFORM

CRCNCL

dame-boundyjump

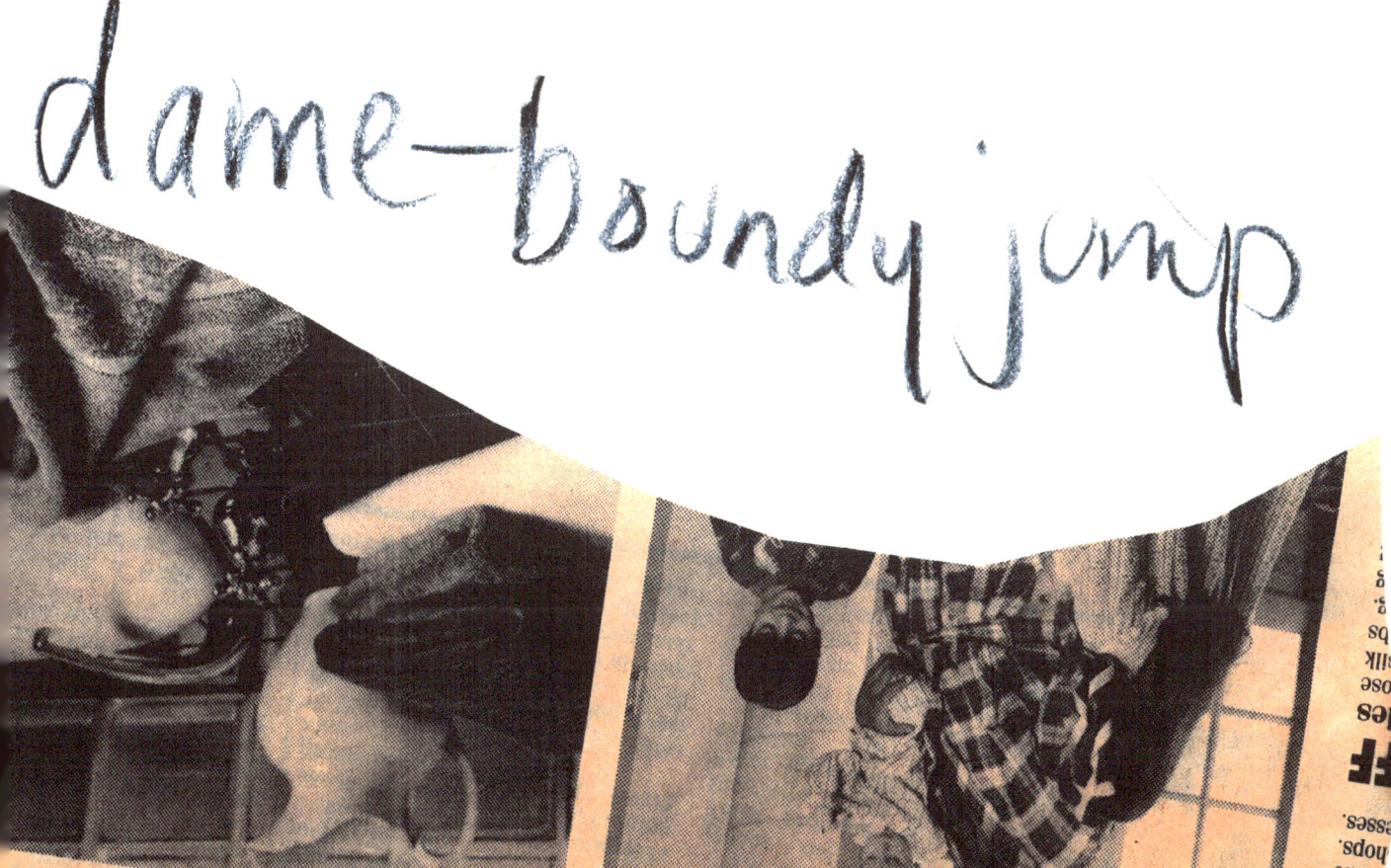

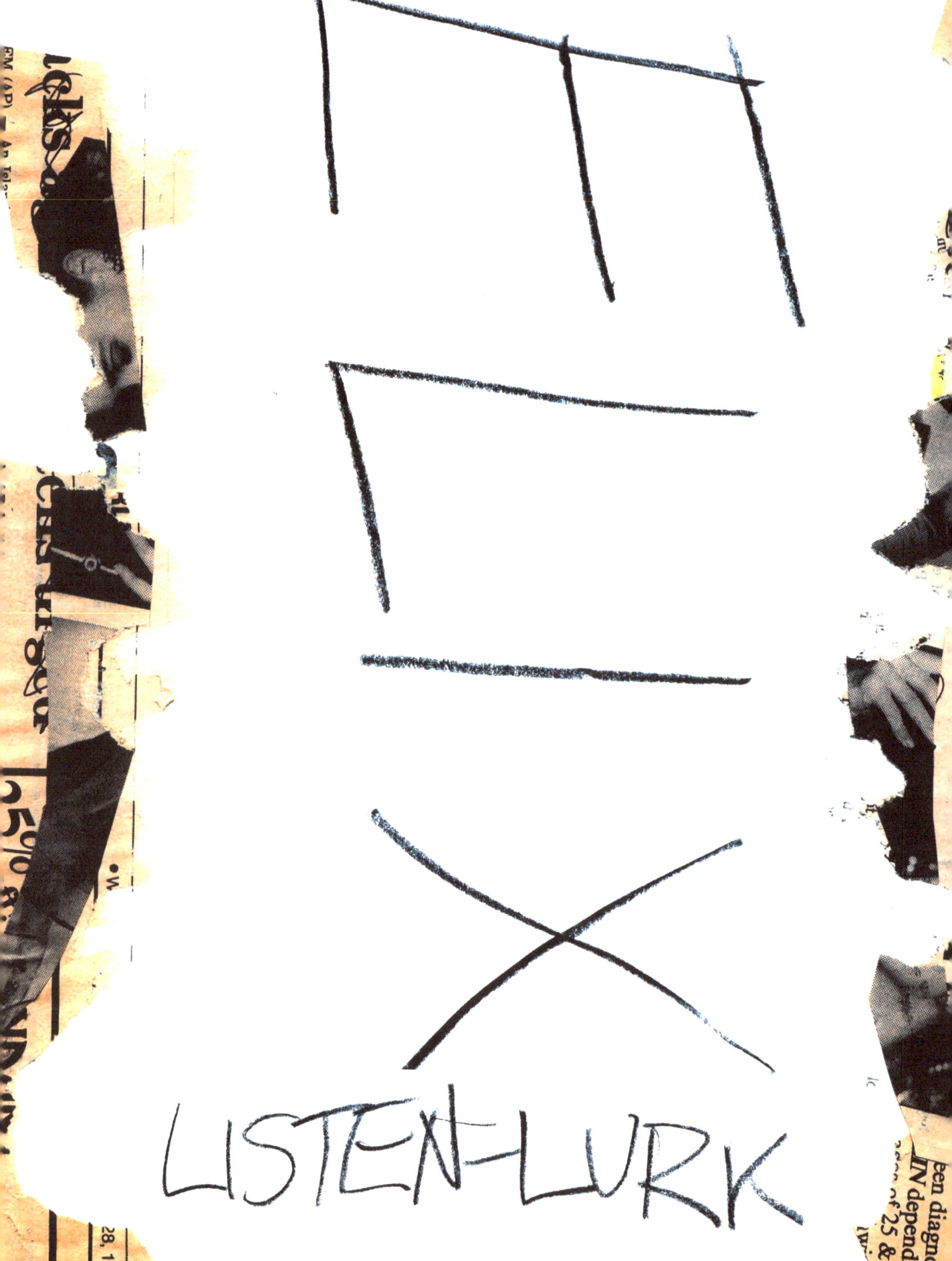

CRCNCL

See arley, see ends, see elapse.
See arches, see endograms, see elephants
Seal armory, seek anger, seem elated.
Sally arm-merchant, sought anchors, seamed elastic.
Call reality, sea-linked masterpieces,
or endochrined medicians travelling boy in a
green plastic. Ace. A.C. Beeb, bib. ACE quoted
"A.E." Whats the cauligan, havermeister zong.

✳ Scrabble/Zou/Blocks/Letters.

CRCNCL
a sur surrealistic

A critical reality can never catch lawlessness.
Dry clear rivers create near crammed liaisons.
And catapulted ~~~~ rigid closets livers.
~~Authors~~ Clever rash could navigate calm luscious.

Climate response claw nurses create lastly.
Clippers really ~~sto~~ callous nurture came late

Caring right caulking non crackling lurched
Calm righteous collicky nervous cranking limit.
Crochety raven clickity notch cavernous lurking.
Couldn't run can't nasty creature livid.
Cream rabid crutches never crass loved
Cavort rifely, claim nothing, call laugh.
Carrot rifle, cabby noodle, carpool lap.
Cottage risky clack nuts cause learning.
Clam ra

Use of found things

Script superimposed behind things

Layers, superimposition

Liz & Miekal do the sound

B&W documentation, 30s — 50s (newsreel)

Animalism, shamanistic gesture + costume

cabalistic texts

1st edit down to 3rd gen, mix

Kitchen terrain, basement terrain, each rooms texture

transparencies, layering

TAPE I

Upstairs:
Zon's B-day party
Kitchen, Gourds, Bern w/ polkadots helmet, & stuffed kitty
~~Advertising~~
~~Cacti, Advertising (hose cardbd),~~ ~~polkadot, Bern~~
~~Cacti~~ Cacti
Garden-hose cardboard & Face-Close up (no helmet)
Mouthing words
Head lying on helmet
Gloved hand writing #'s on his face
Bern up towards ceiling (looking up at him)
Teeth (use sound)
Kitchen word on plastic (blender sound), wool hat
balloon + candle ~~~~
lifting shirt close-up (flute)
"It's nice to." guitar

Downstairs:
~~~~ Music room (sound) book
Caressing words in book
Medalion w/ words close-ups
~~walking down~~ stairs to basement & hat
basement furnishing/texture, wood & metal, walls
walking upstairs-pan from walls
" through back stairwell to 2nd floor
Objects in front stairwell & walking up

Office files, hangings, etc.
In office closet
Livingroom marble ramp (sound), depth
Scrabble game — letters & interaction
Hat & berrets
Overhead shot of game
Both with book — hats
Zan drawing on book ~~beads~~
letter-stickers on book — on hands
painting both Zan & Bern's faces
Zan paints Bern's face
words around ceiling in livingroom
bead game
   words by bern spoken, Zan has cassette
helmet, polka-dot sheet  going through basket
~~beads &~~  plastic words scrolling
office closet ———→ Bern goes in, Zan comes out
2nd TAPE  ~~pans~~ around ~~room~~  workroom
bathroom — painting in bathtub nude
downstairs closet
Bern & mask — Sofia's room — Zan out of closet
Bern naked in Sofia's room
Interaction in closet
bathroom — painting on body — Zan w/ plunger

bathroom w/ 3 mirrors — face close-up
Gillespie book
re-photos — photo of Gillespie
stills of Gillespie at different ages
Zan in office with words on back
Red wig in living room
Zan down back stairwell (where's Bern?)
Liz holds Zan — words
Front stairwell final

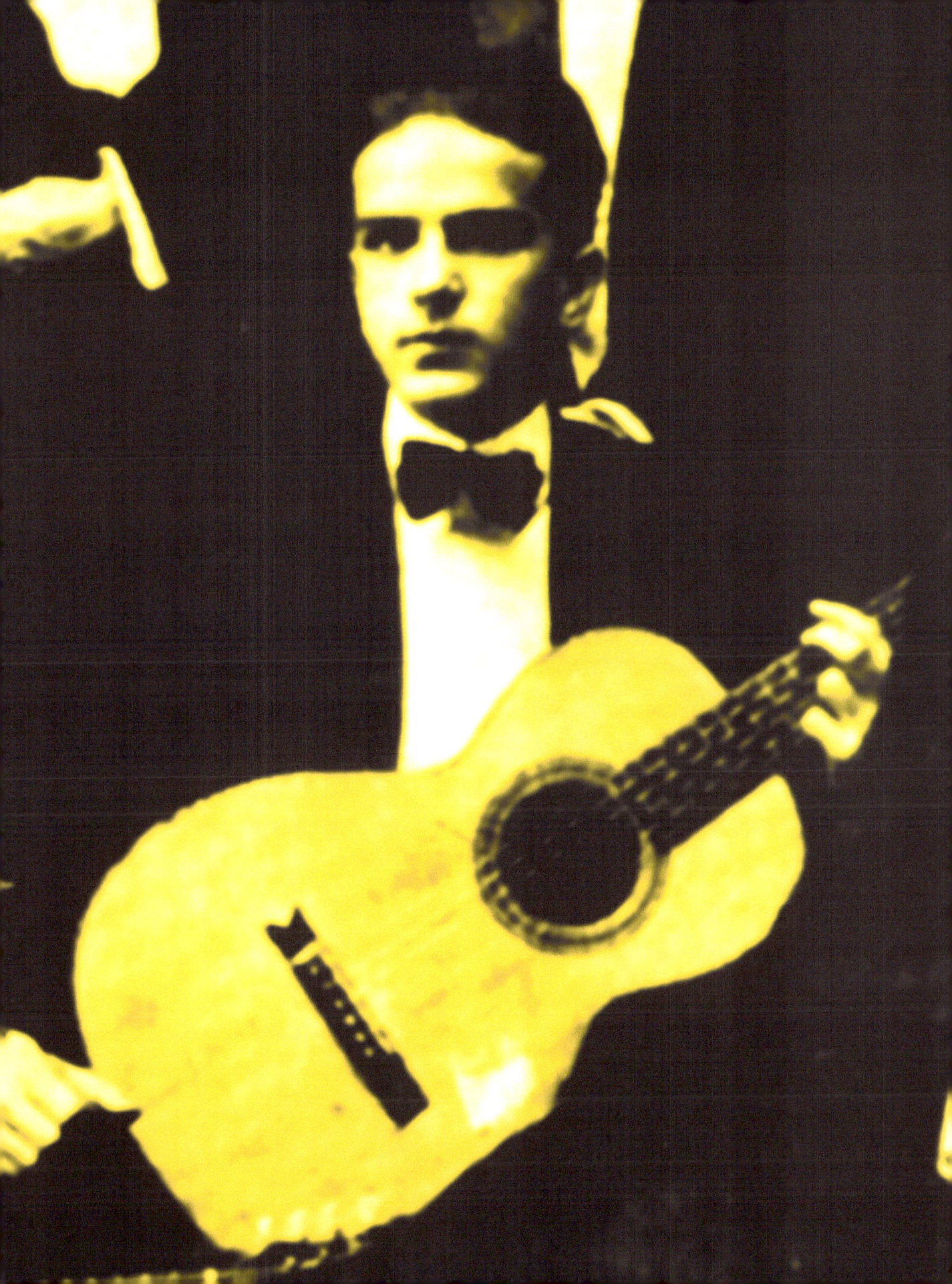